A Keepsake

CHARLESTON

Antelo Devereux Jr.

4880 Lower Valley Road • Atglen, PA 19310

"*She guards her buildings, customs, and laws.*"

—*City Motto*

Probably more than the city's many churches, Greek revival buildings, columns, brick walls, live oak trees, and dangling Spanish moss, this small plaque symbolizes Charleston's successful efforts to preserve itself.

INTRODUCTION

Charleston was founded in 1670 on land granted to eight proprietors by English King Charles II. Known as the "Merry Monarch," his love of life and its pleasures more than likely set a tone that appears to have been carried forward to the present. A survivor of two wars, five major fires, several hurricanes, and a devastating earthquake, Charleston flourishes. The city's buildings, houses, gardens, and people exude history, charm, southern grace, and beauty.

These photographs are a sampling of the past and present flavor of this wonderful city and its people. I hope the reader finds them as entertaining to look at as I did making them.

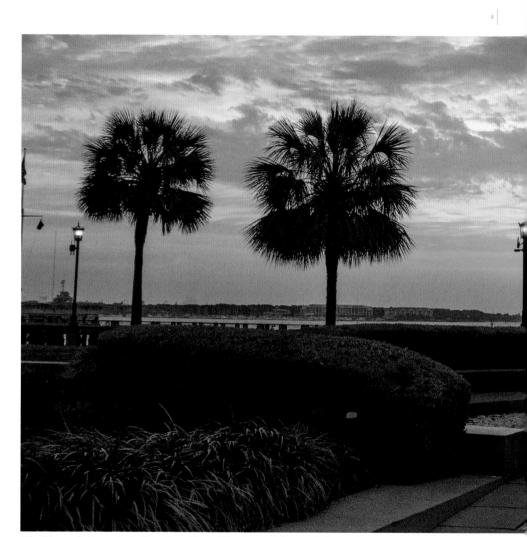

The Pineapple Fountain in Waterfront Park. The pineapple is a symbol of welcome.

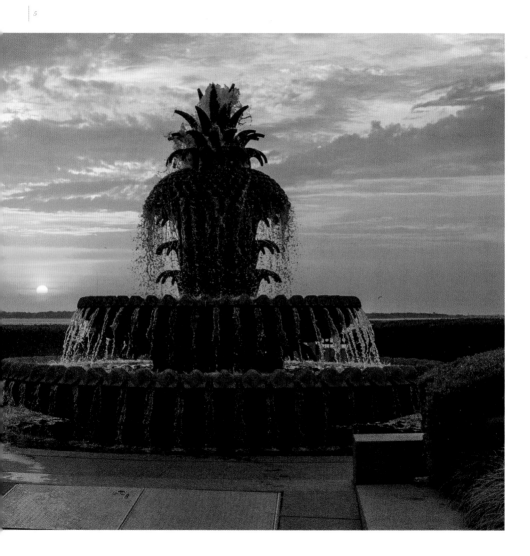

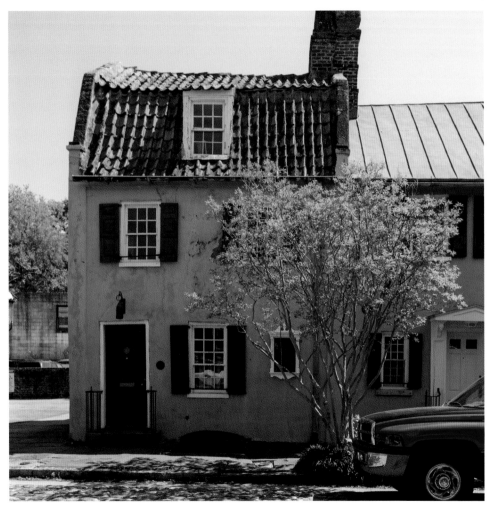

The Pink House, Chalmers Street.

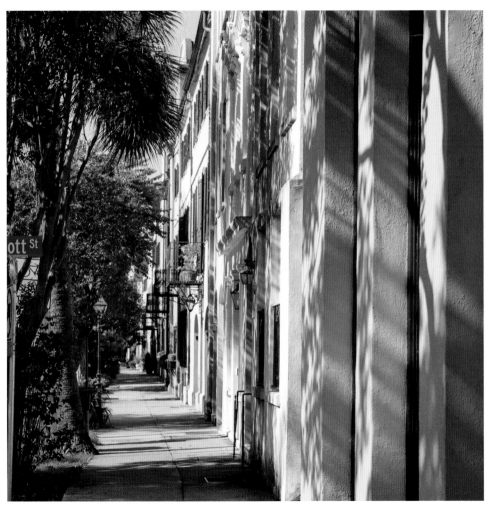

Rainbow Row, East Bay Street.

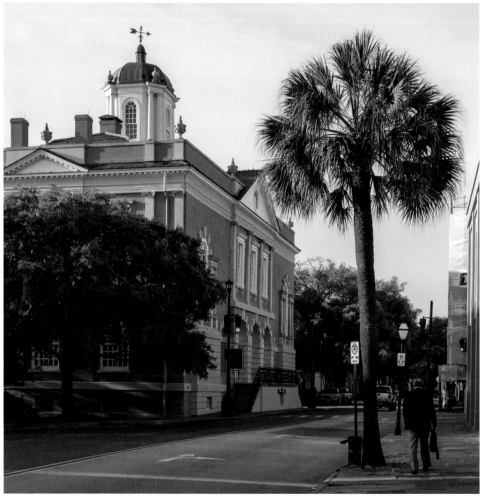

Old Exchange and Provost Dungeon, 1771, East Bay Street.

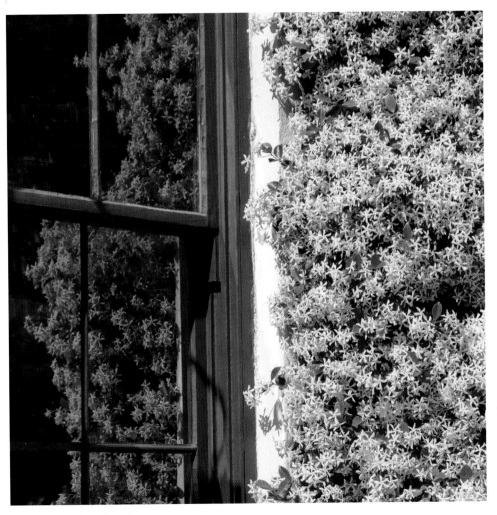

Jasmine abounds in the spring.

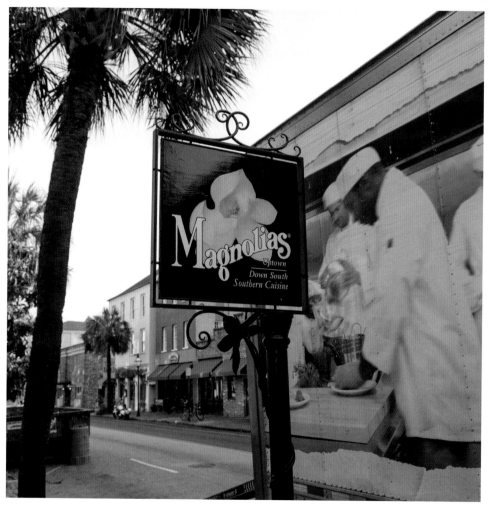

East Bay Street.

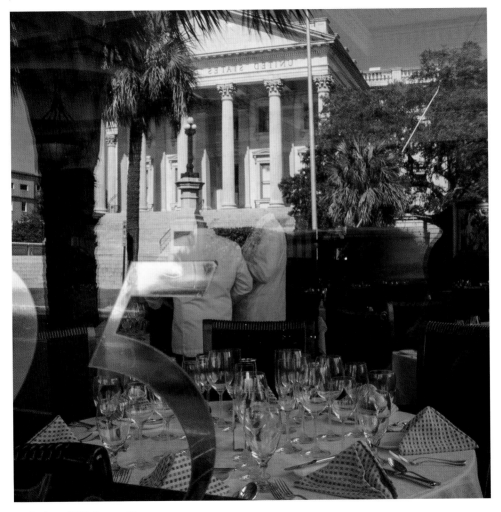

Reflection of US Custom House.

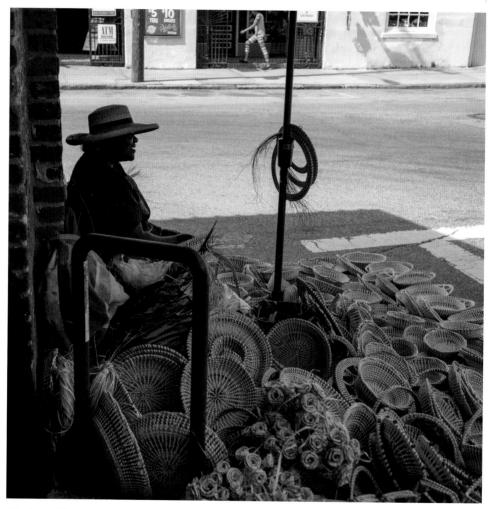

Charleston City Market, Market Street.

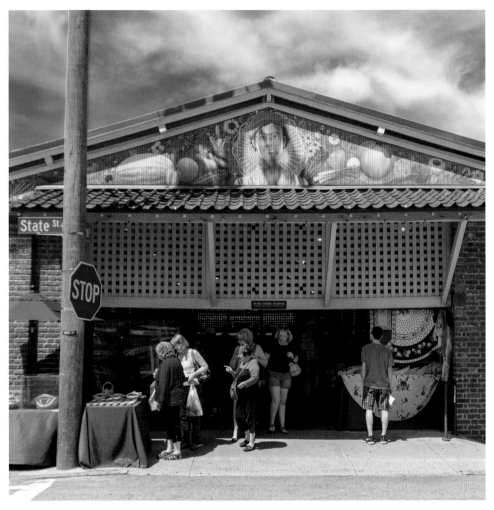

Charleston City Market, Market Street.

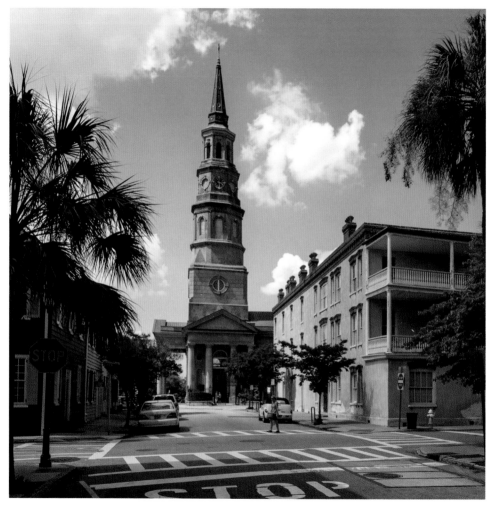

Saint Philip's Episcopal Church, 1835, Church Street.

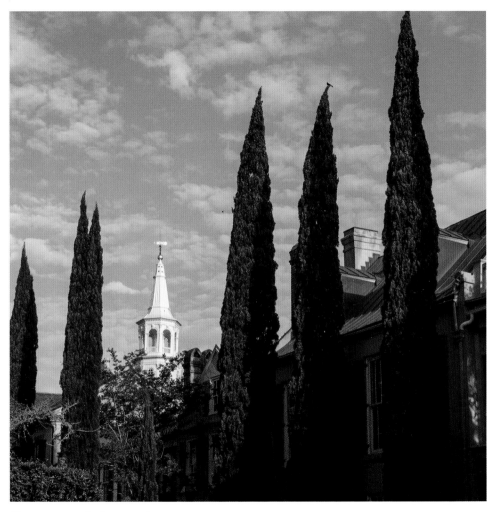

Tuscan cypress, also known as drama trees.

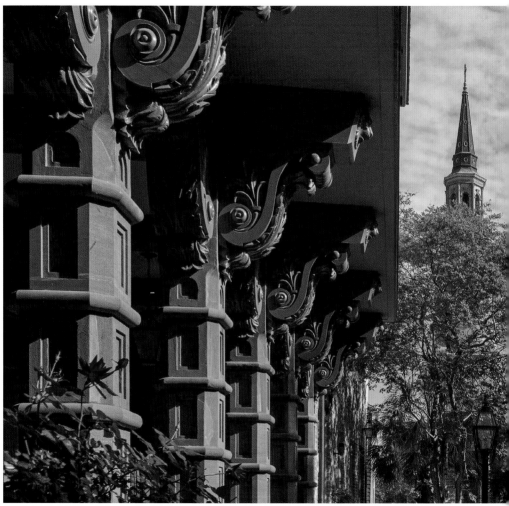

Dock Street Theatre.

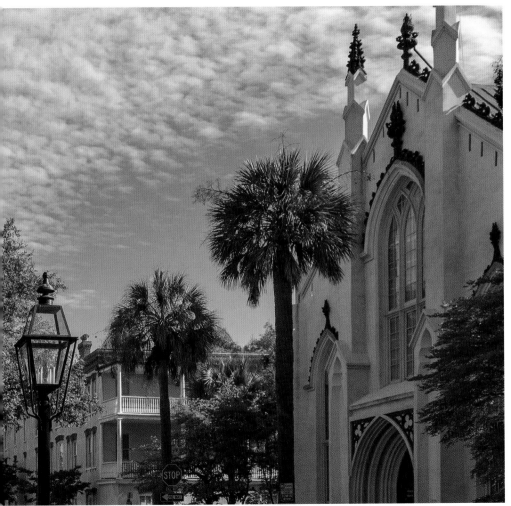

Huguenot Church, Church Street.

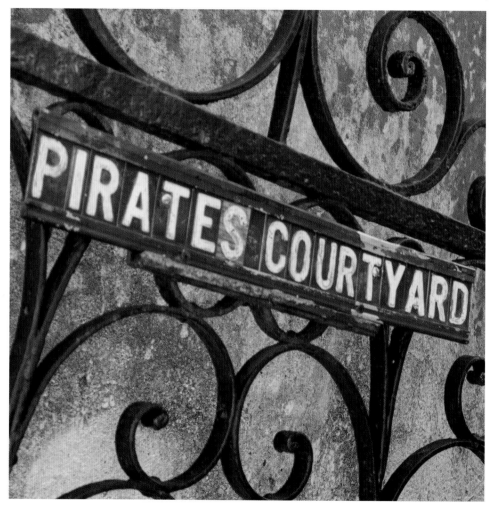

Pirates did live in Charleston.

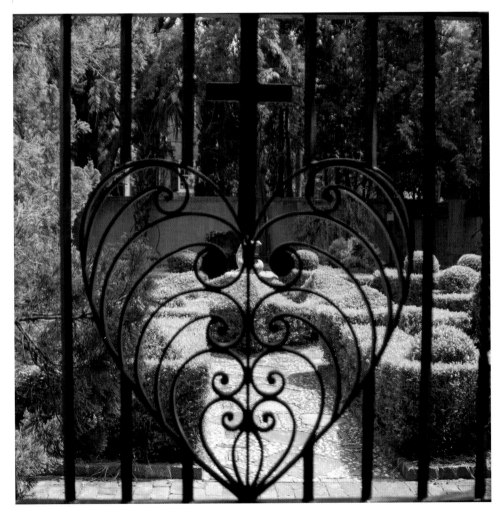

Gate designed by famed blacksmith, Philip Simmons.

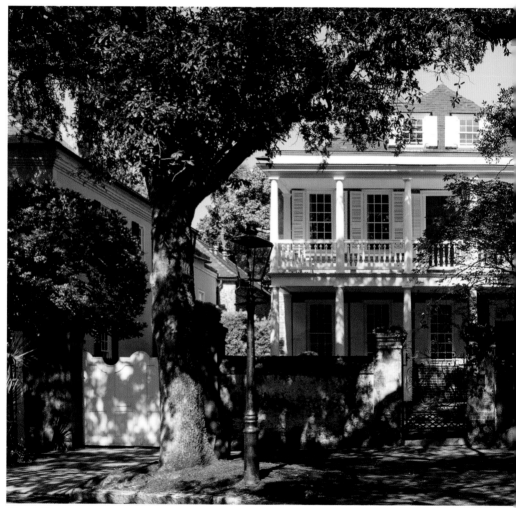

Church Street.

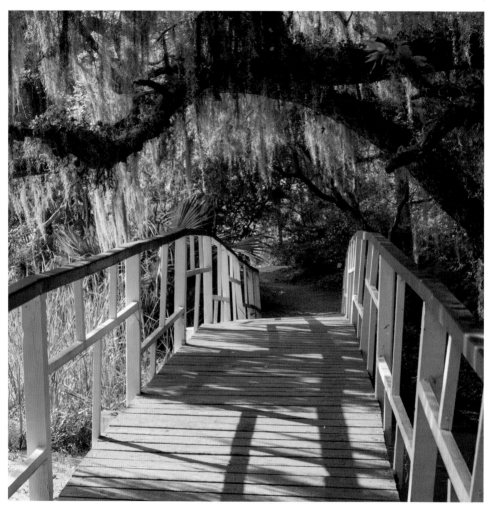

Magnolia Gardens.

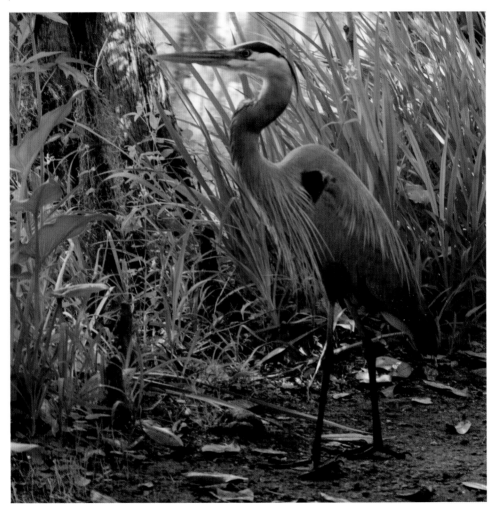

Great blue heron, Magnolia Gardens.

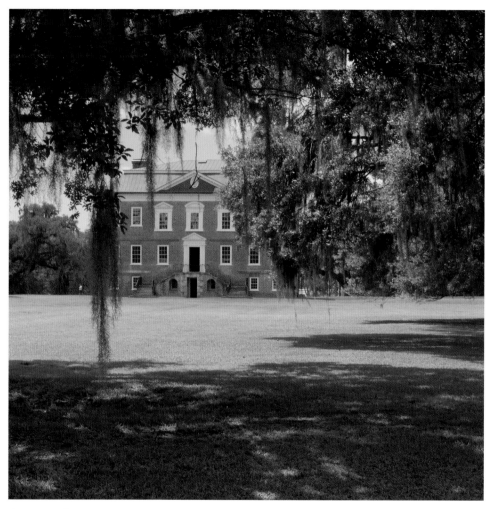

Drayton Hall.

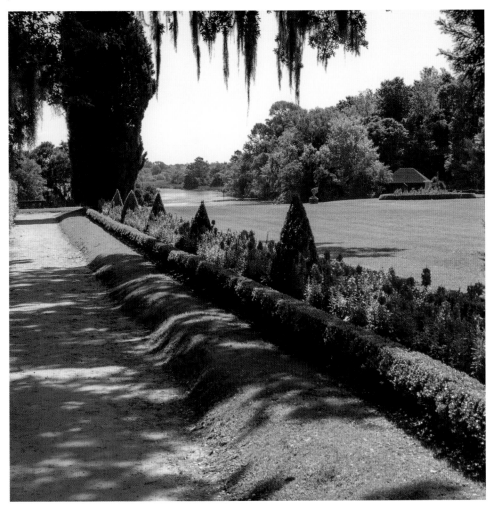

Middleton Place.

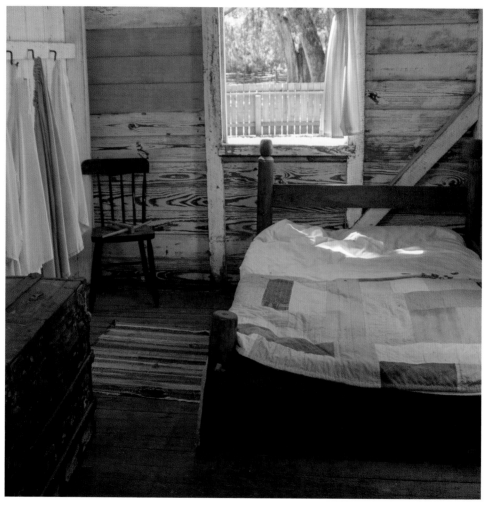

Eliza's House, Middleton Place.

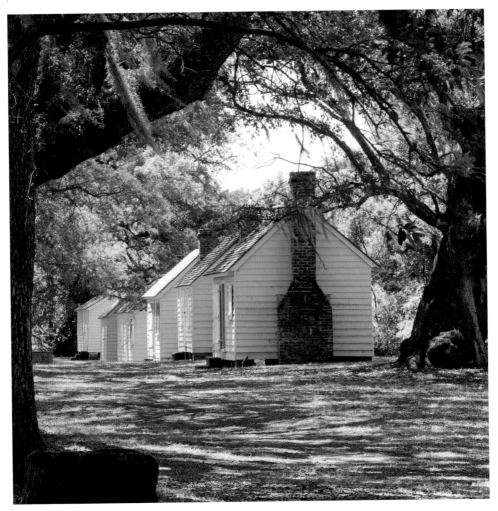

McLeod Plantation, James Island.

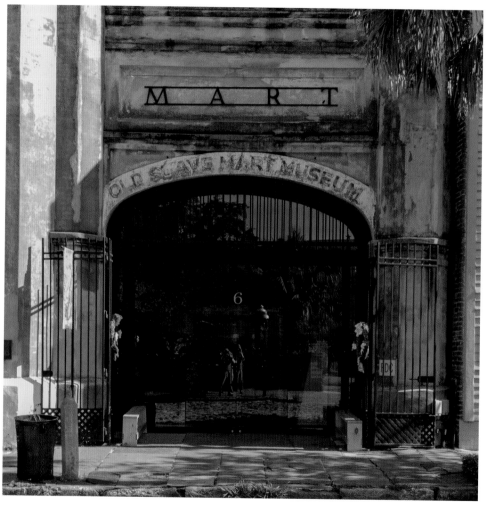

Old Slave Mart Museum, Chalmers Street.

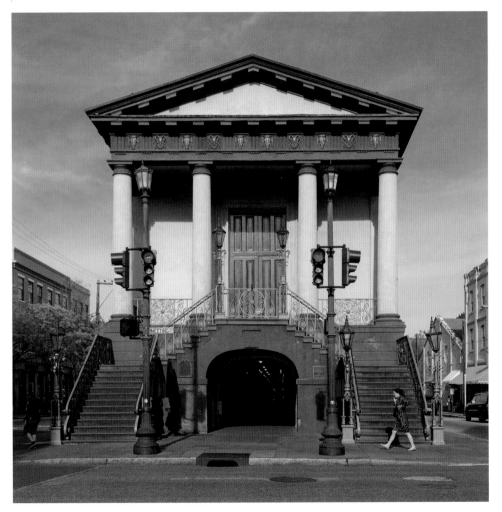

Market Hall, 1841, Meeting and Market Streets.

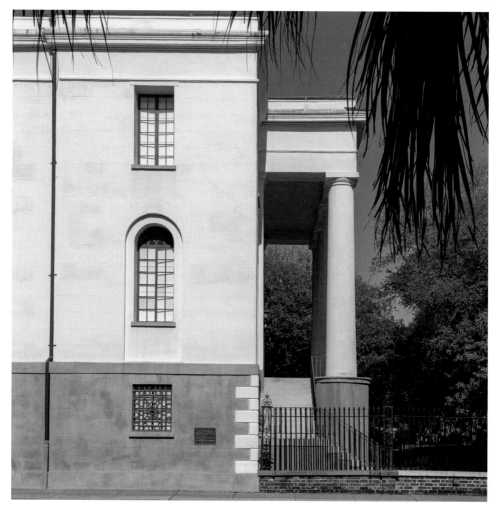

Fireproof Building, 1827, Meeting Street.

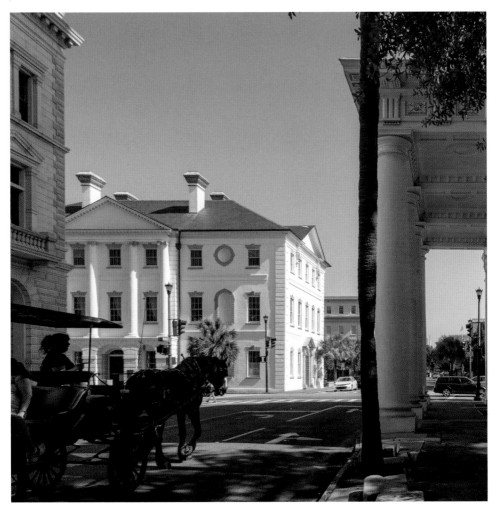

Four Corners of Law.

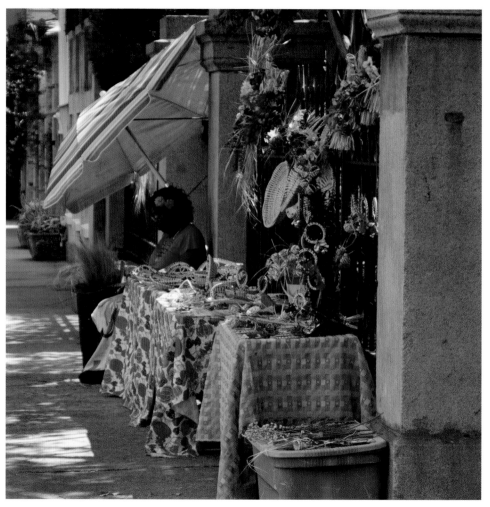

The "flower ladies" sell wonderfully crafted sweetgrass baskets.

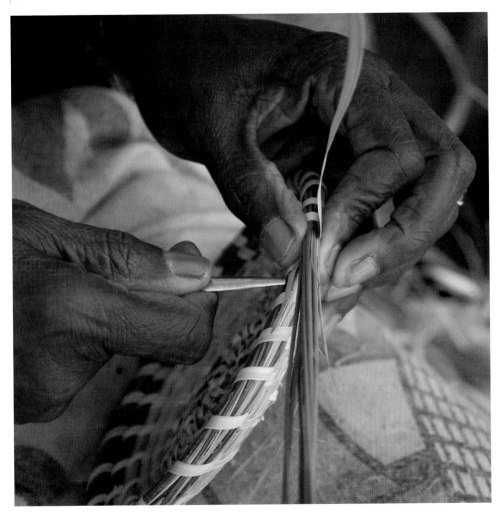

Basket in the making.

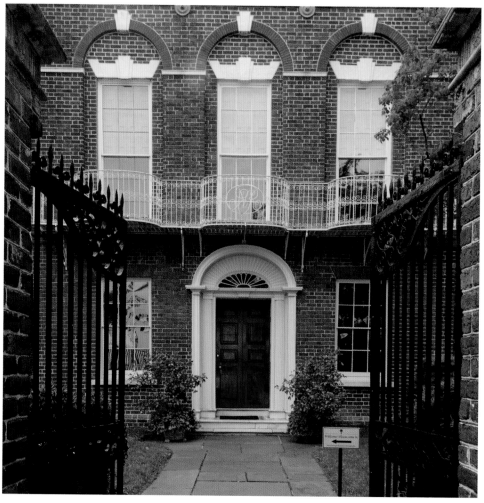

Nathaniel Russell House, 1808, Meeting Street.

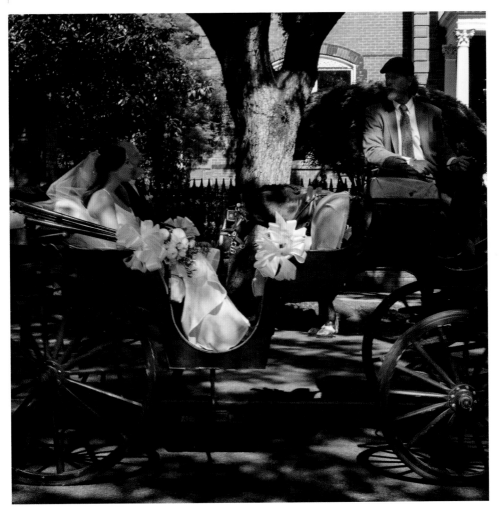

Meeting Street.

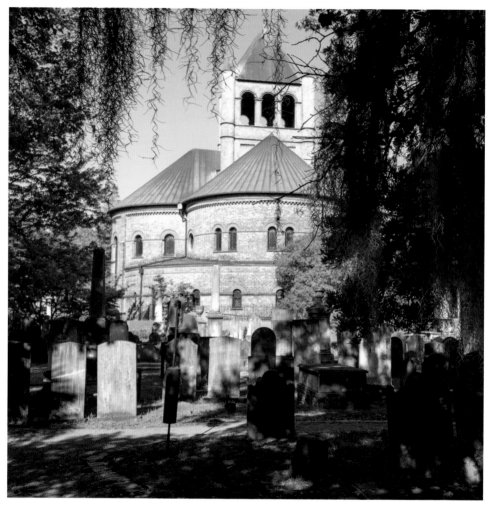

Circular Congregational Church, Meeting Street.

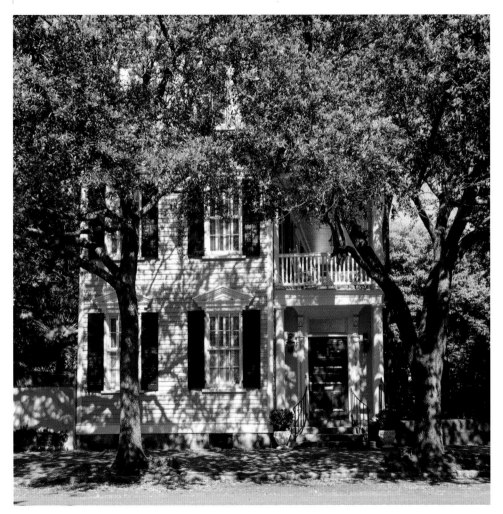

House on Meeting Street.

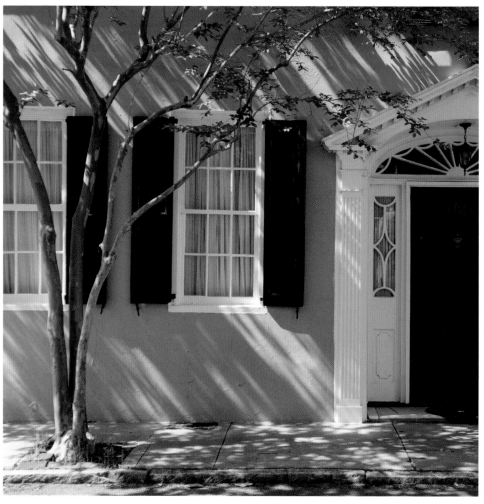

House on Tradd Street.

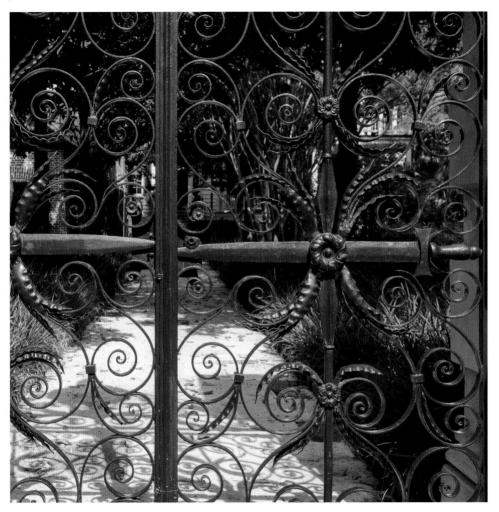

Sword Gate, Legare Street.

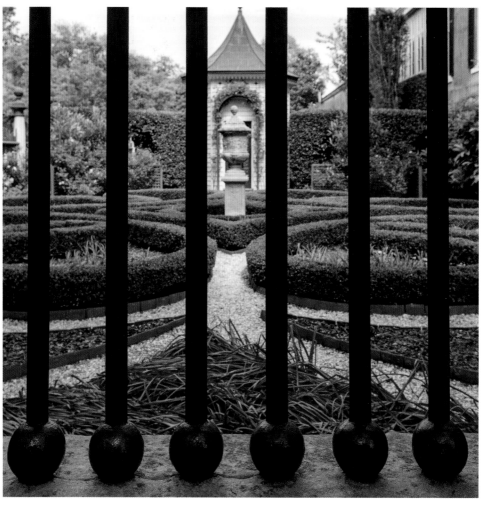

Legare Street.

South Battery Street.

Twining roses.

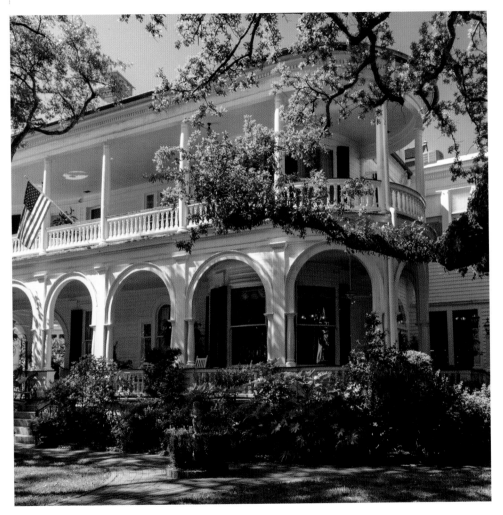

Two Meeting Street Inn.

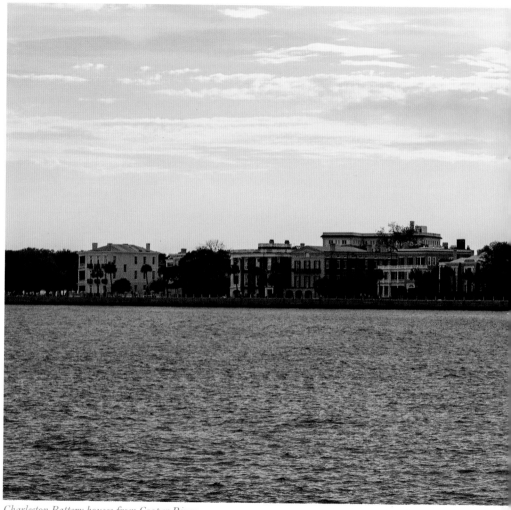

Charleston Battery houses from Cooper River.

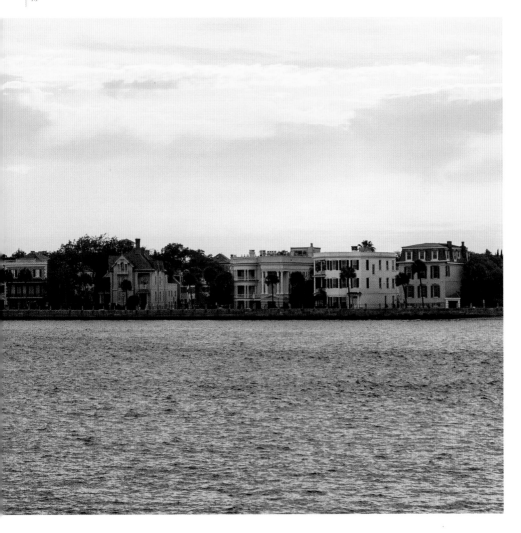

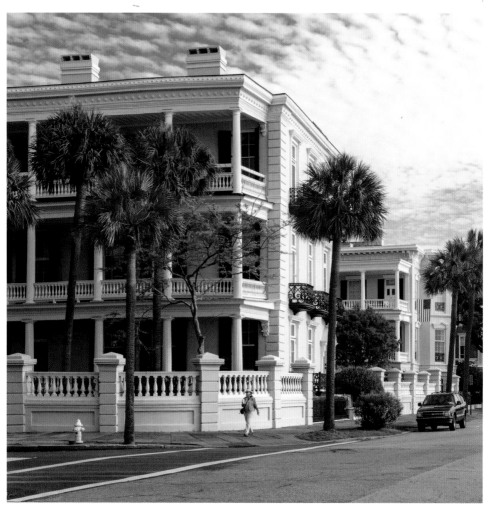

East Battery Street.

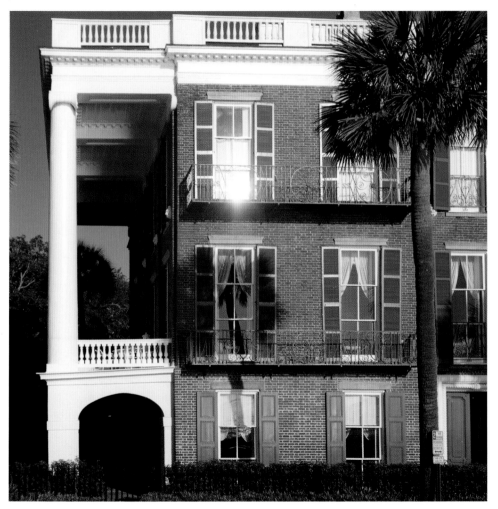

Roper House, East Battery Street.

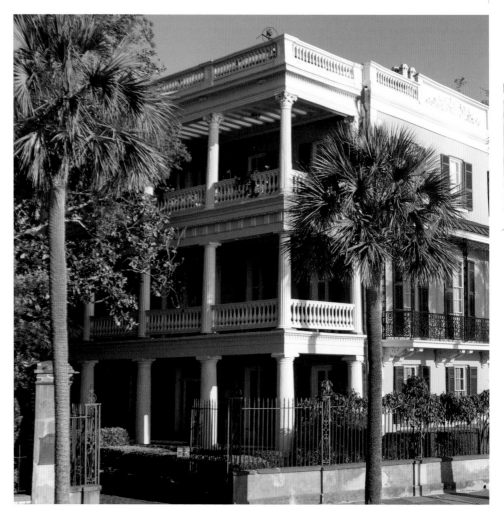

Edmonston-Alston House, East Battery Street.

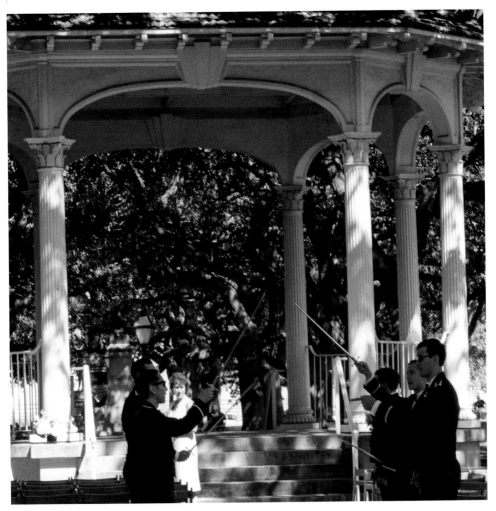

Bandstand, White Point Garden.

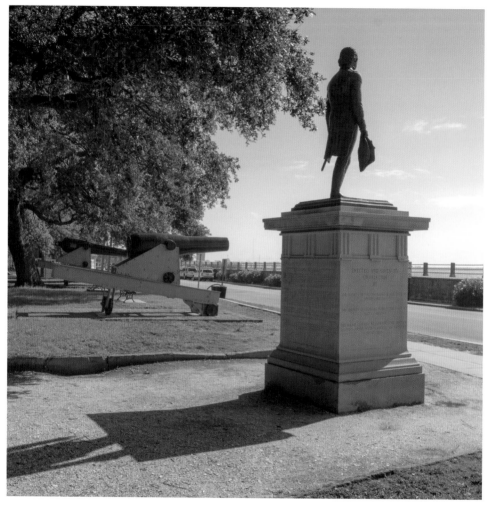

General Moultrie looks toward his eponymous fort.

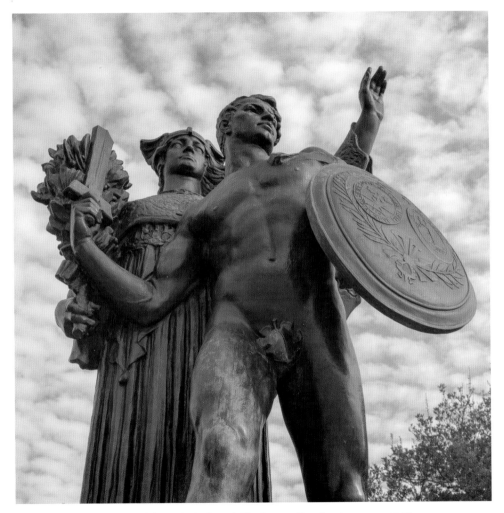

Commemoration "To the Confederate Defenders of Charleston – Fort Sumter 1861–1865."

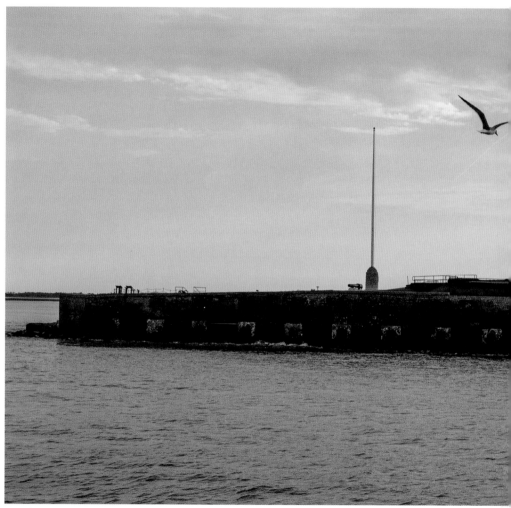

Fort Sumter.

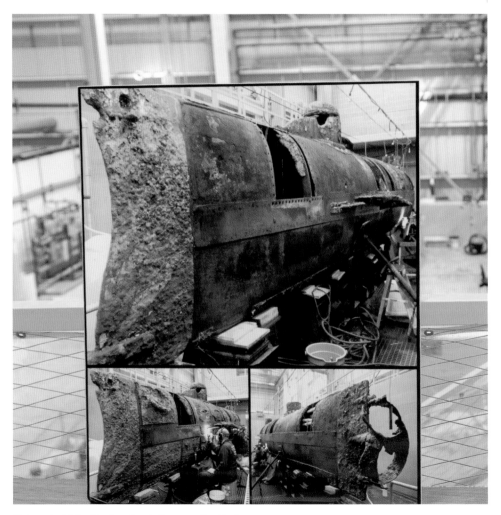

Submarine H. L. Hunley, *Lasch Conservation Center.*

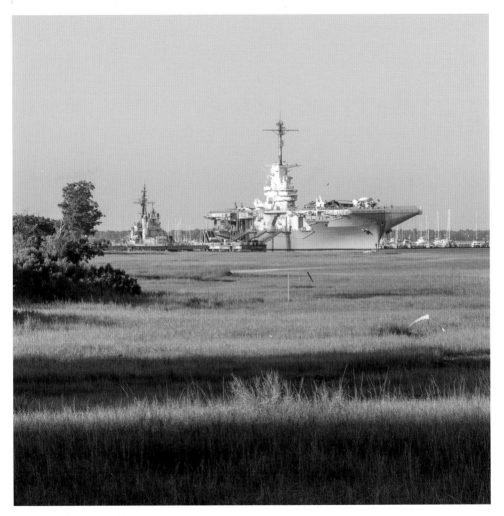

Patriots Point, Mount Pleasant.

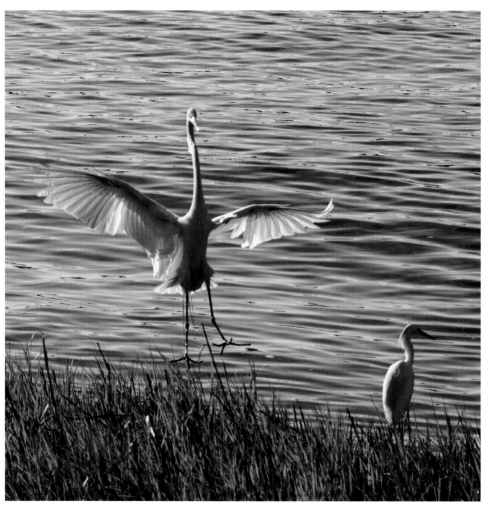

Egrets.

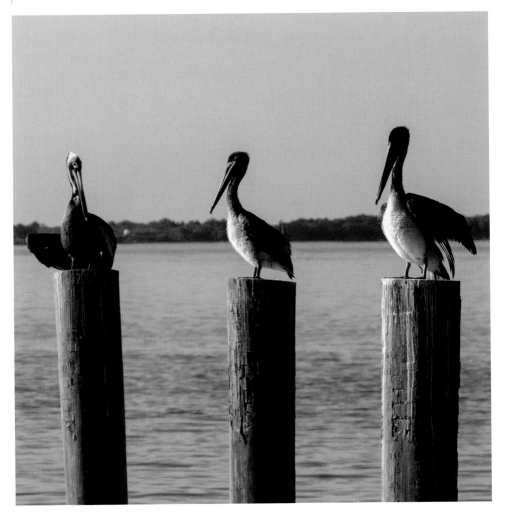

Pelicans.

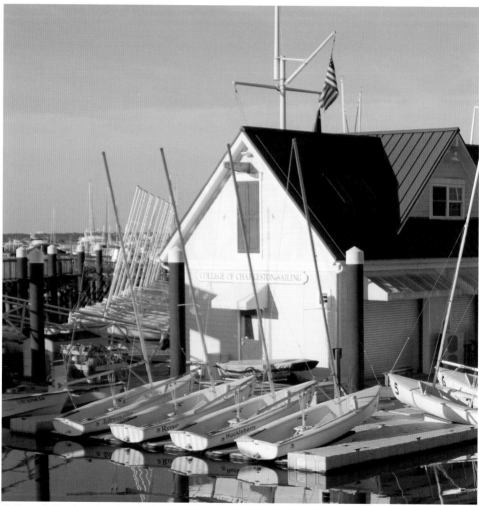

College of Charleston's sailing facility, Patriots Point.

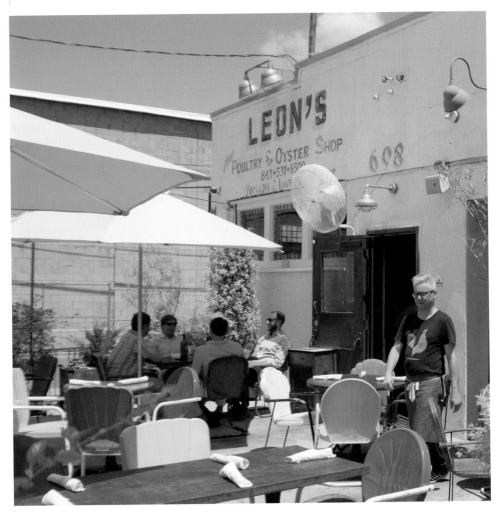

Fresh seafood and oysters abound.

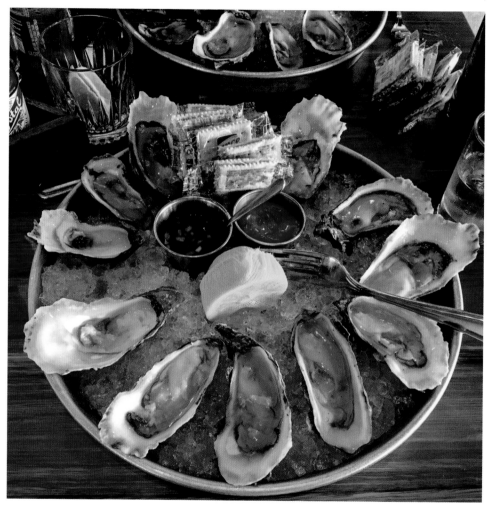

Oysters on ice.

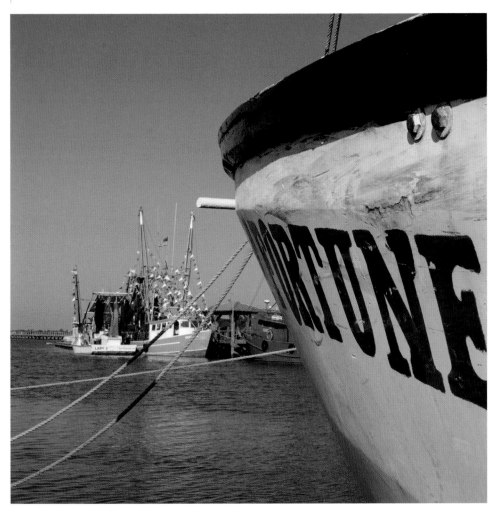

Shrimp boats, Shem Creek, Mount Pleasant.

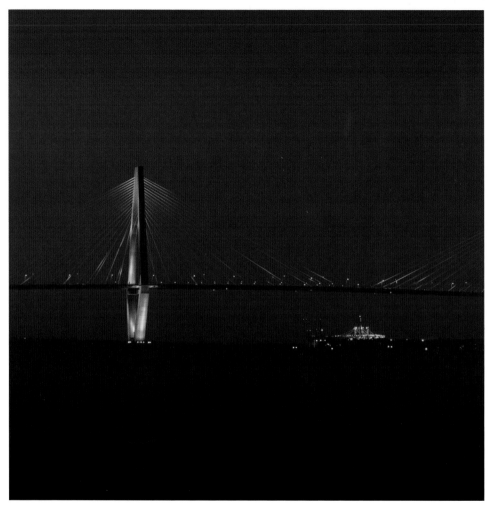

Arthur Ravenel Jr. Bridge.

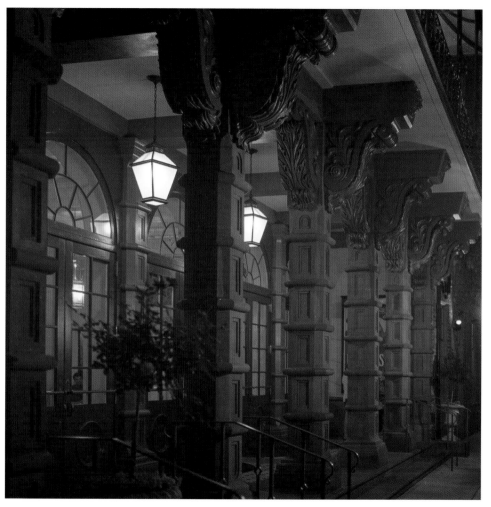

Dock Street Theatre, Church Street.

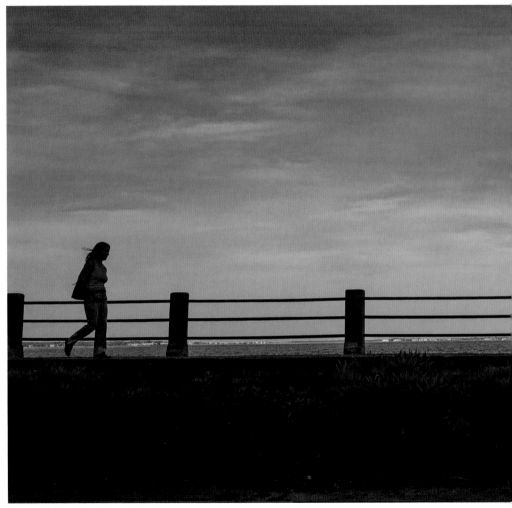

Sea wall along East Battery Street.

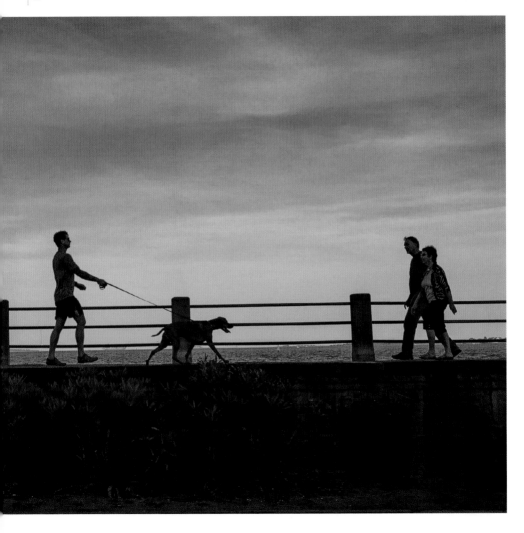

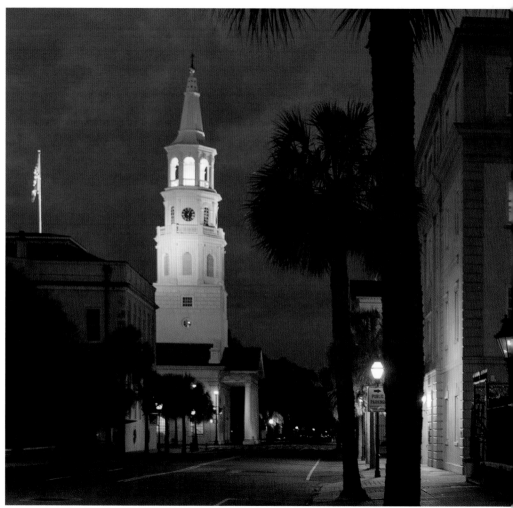

Saint Michael's Episcopal Church, Broad Street.

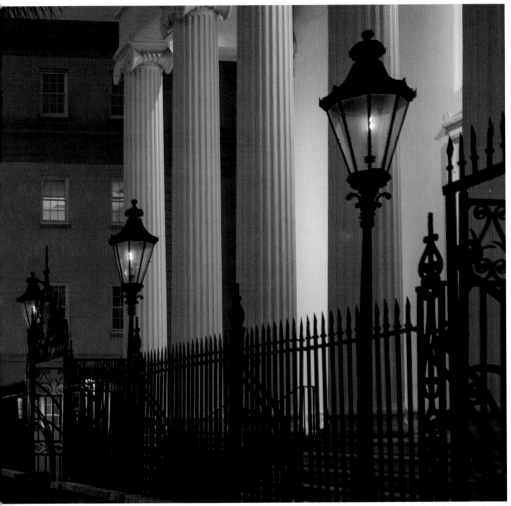

Hibernian Society, Meeting Street.

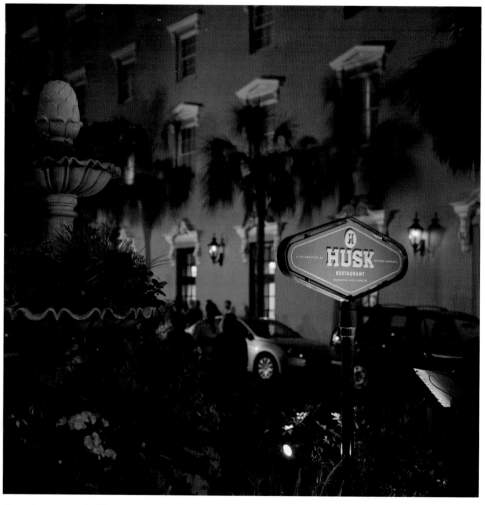

One of many wonderful restaurants.

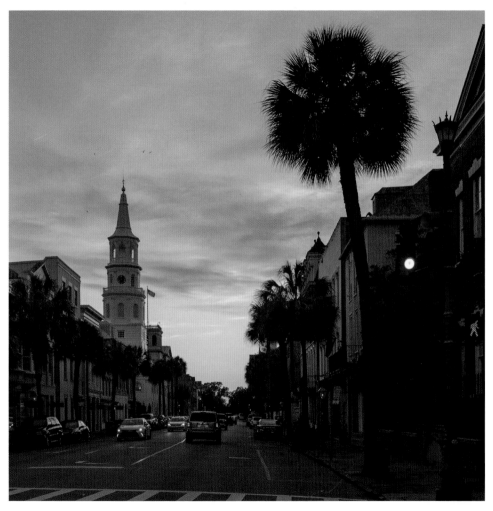

Saint Michael's Episcopal Church, Broad Street.

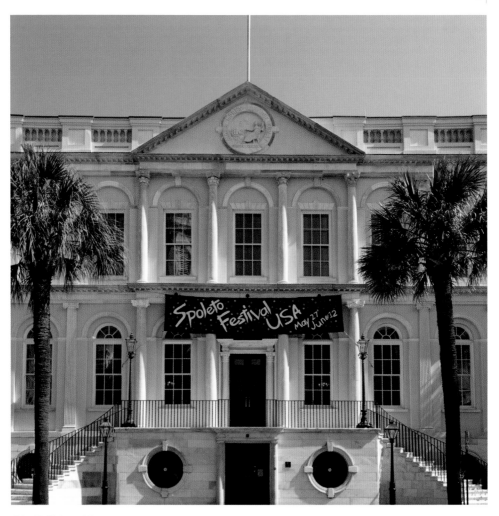

City Hall, Broad Street.

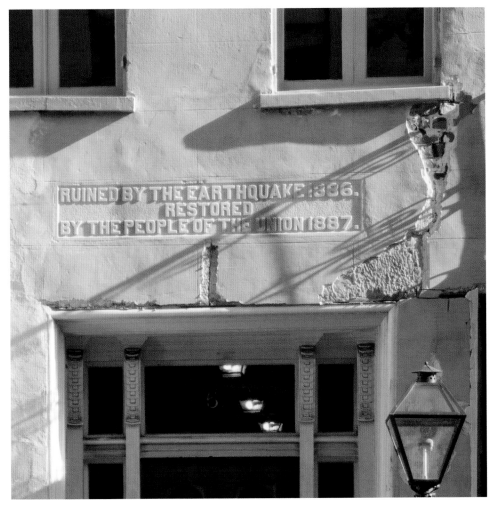

Earthquake-damaged building, Broad Street.

Broad Street.

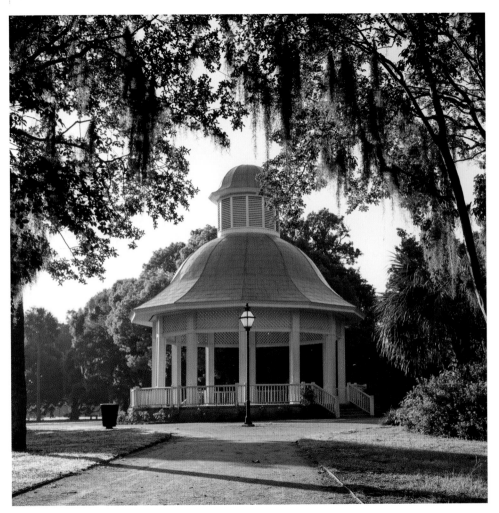

Bandstand, Hampton Park.

The Citadel.

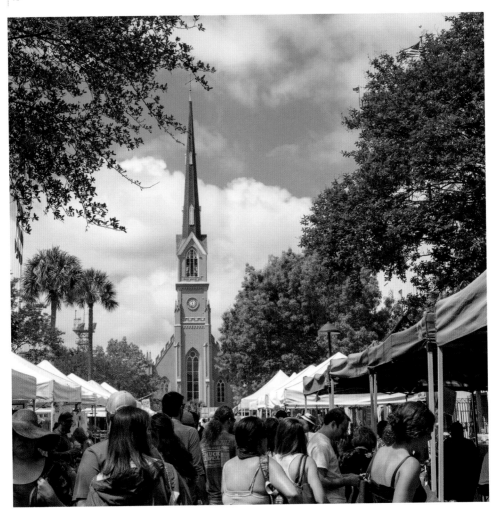

Farmers Market, Marion Square.

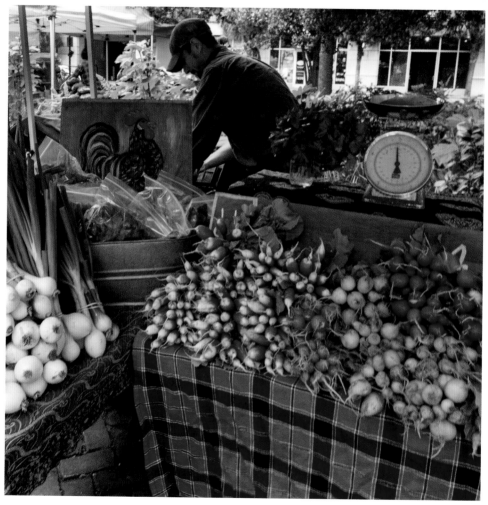

Farmers Market, Marion Square.

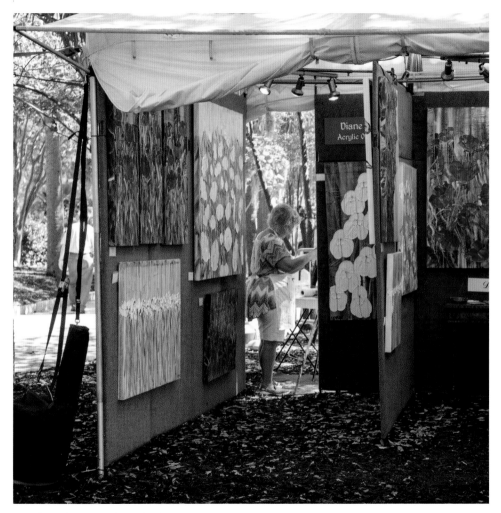

Piccolo Spoleto Festival, Marion Square.

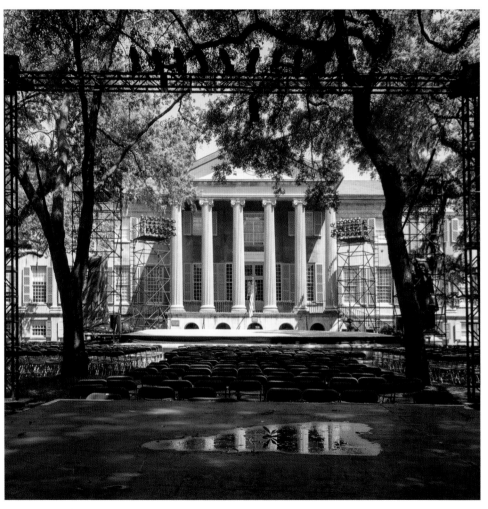

Randolph Hall, College of Charleston.

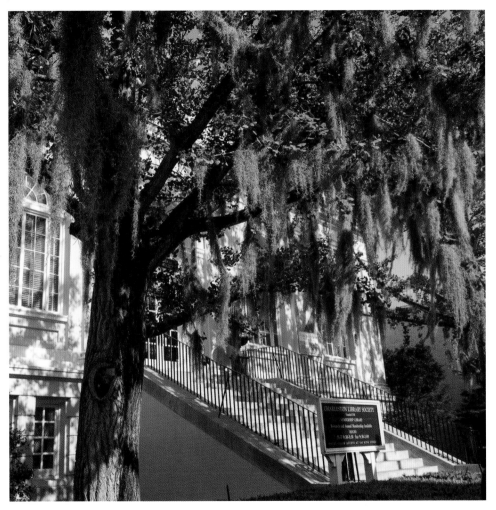

Charleston Library Society, King Street.

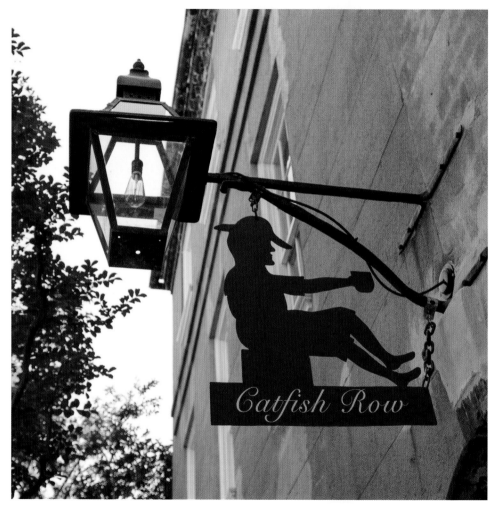

Reference to Porgy and Bess, *Cabbage Row, Church Street.*

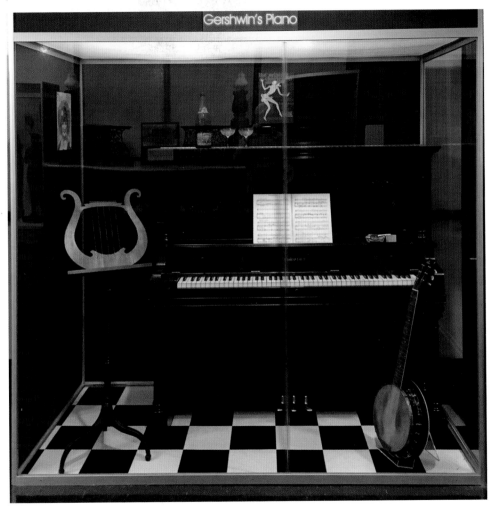

George Gershwin's piano, Charleston Museum.

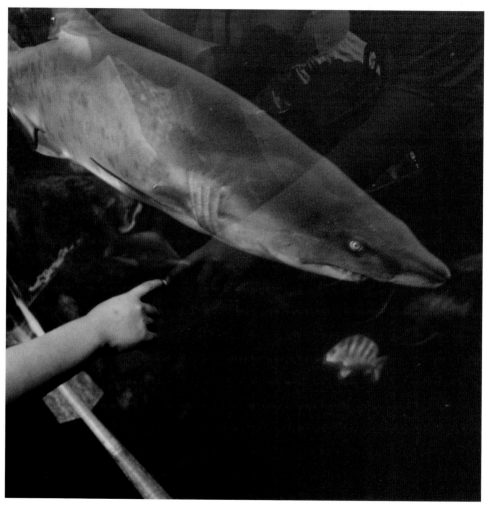

South Carolina Aquarium.

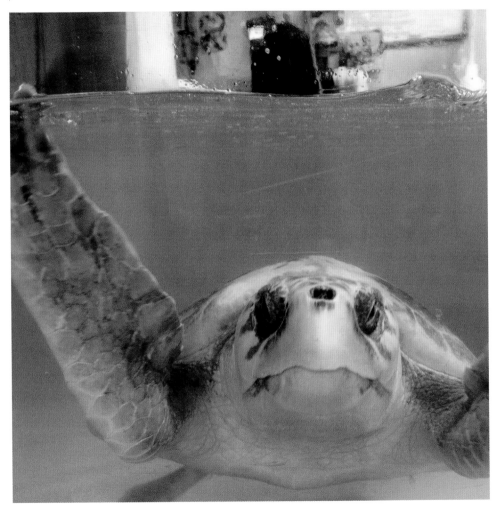

Sea Turtle Hospital, South Carolina Aquarium.

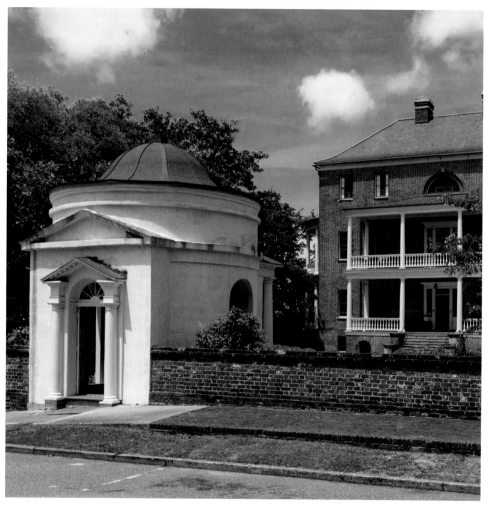

Joseph Manigault House, Meeting Street.

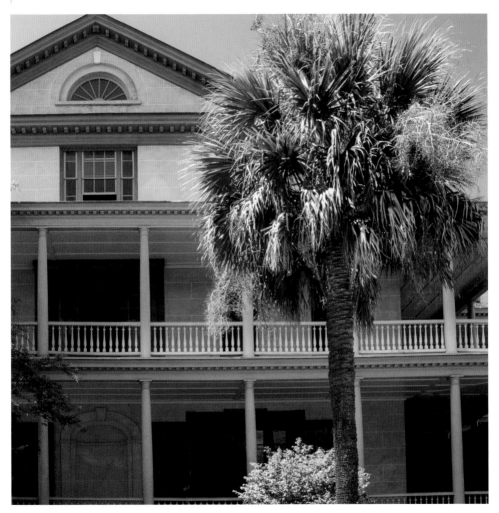

Aiken-Rhett House, Elizabeth Street.

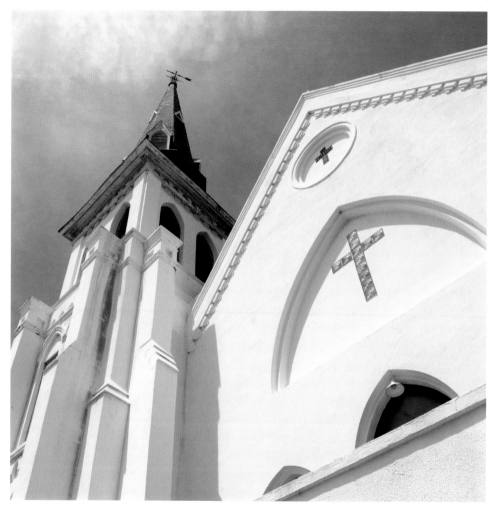

Mother Emanuel African Methodist Episcopal Church, Calhoun Street.

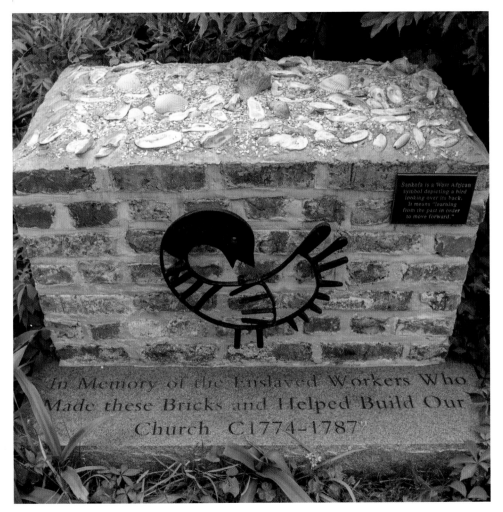

Cemetery, Unitarian Church, Archdale Street.

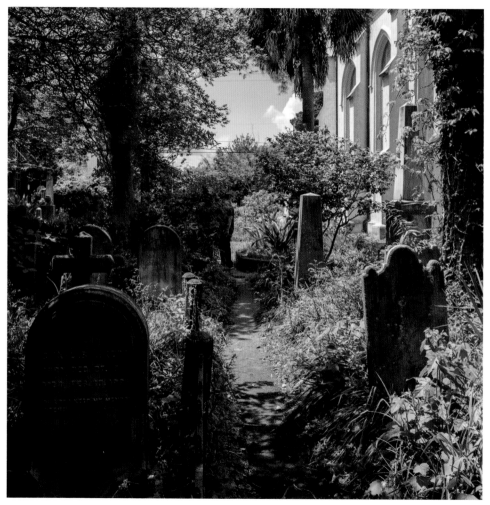

Naturally planted cemetery, Unitarian Church, Archdale Street.

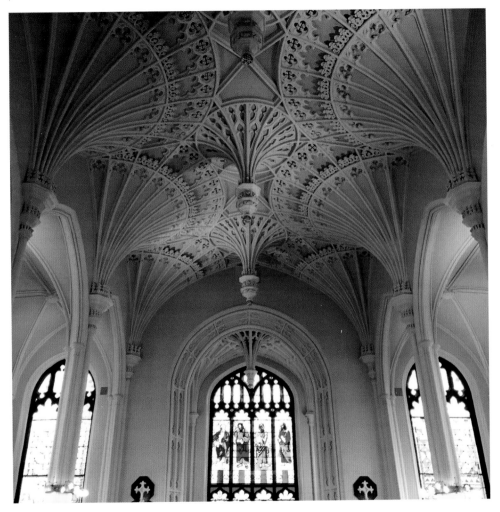

Unitarian Church, Archdale Street.

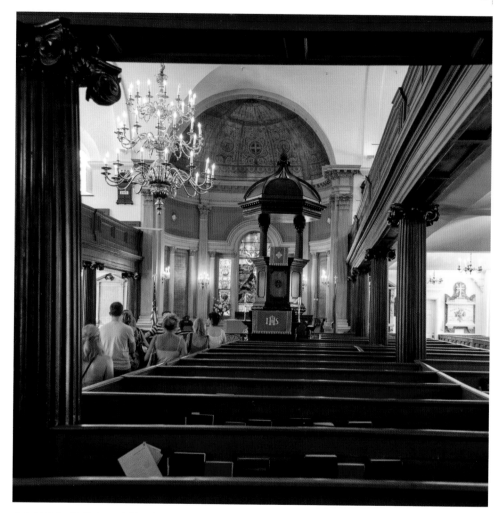

Saint Michael's Episcopal Church, Meeting and Broad Streets.

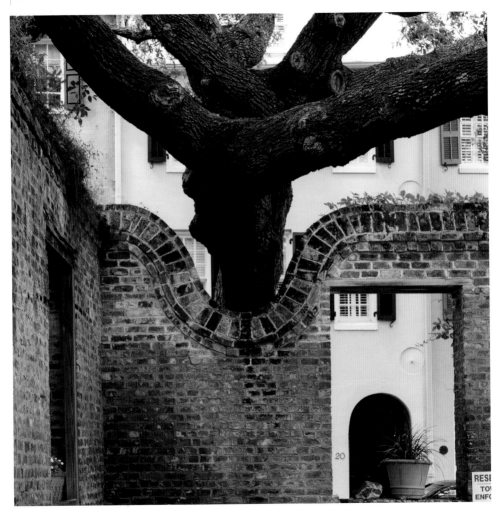

Brick wall meets live oak tree.

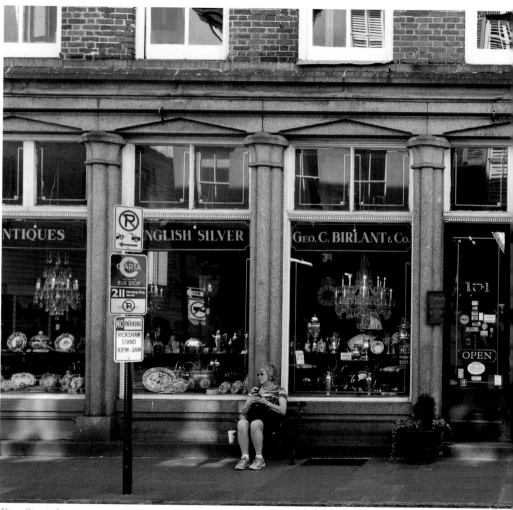

King Street shops.

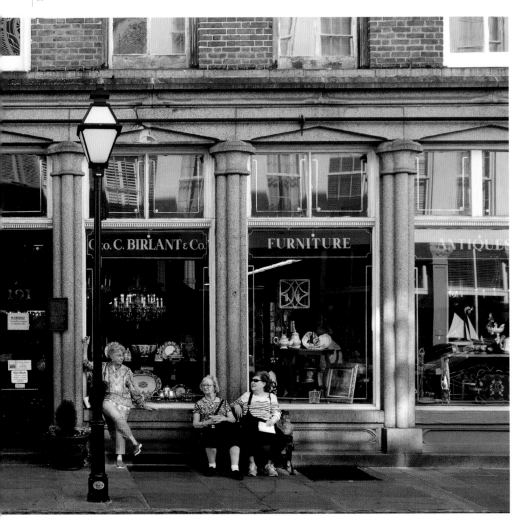

King Street shops.

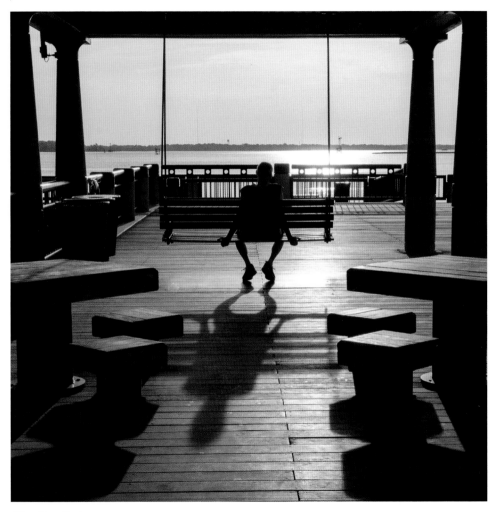

Waterfront Park.

Antelo Devereux Jr. has been photographing most of his life, first as an amateur and more recently as a professional. He has published six books and has exhibited his images in various venues and galleries in Pennsylvania, Delaware, Vermont, and Maine. He has degrees from Harvard University and the University of Pennsylvania and has studied at the Maine Media Workshops. He lives with his family in Chester County, Pennsylvania.

Other Schiffer Books by Antelo Devereux Jr.:
Chester County Out & About
ISBN 978-0-7643-3625-6
Maine Coast Perspectives
ISBN 978-0-7643-3015-5
Eastern Shore Perspectives
ISBN 978-0-7643-4446-6

Designed by Molly Shields
Type set in Bell MT

ISBN: 978-0-7643-5337-6

Printed in China

Published by Schiffer Publishing, Ltd.
4880 Lower Valley Road
Atglen, PA 19310
Phone: (610) 593-1777; Fax: (610) 593-2002
E-mail: Info@schifferbooks.com
Web: www.schifferbooks.com

For our complete selection of fine books on this and related subjects, please visit our website at www.schifferbooks.com. You may also write for a free catalog.

Schiffer Publishing's titles are available at special discounts for bulk purchases for sales promotions or premiums. Special editions, including personalized covers, corporate imprints, and excerpts, can be created in large quantities for special needs. For more information, contact the publisher.

We are always looking for people to write books on new and related subjects. If you have an idea for a book, please contact us at proposals@schifferbooks.com.